DIGITAL
SOLIDARITY

FELIX STALDER

GW00750537

A collaboration between the Post-Media Lab
& Mute Books

Please email mute@metamute.org with any details of
republication

Co-published as a collaboration between Mute and the
Post-Media Lab, Leuphana University.
PML Books is a book series accompanying the work of the
Post-Media Lab. http://postmedialab.org

Print ISBN: 978-1-906496-92-0
Also available as eBook 978-1-906496-93-7

Distribution Please contact mute@metamute.org for trade and
distribution enquiries

Acknowledgements

Series Editors Clemens Apprich, Josephine Berry Slater,
Anthony Iles and Oliver Lerone Schultz
Layout Raquel Perez de Eulate
Design Template Based on a template by Atwork
Cover Image Simon Worthington

PML Books

The PML Book series is a collaboration between Mute
magazine and Post-Media Lab. The Lab was set up in
September 2011 and explores how post-broadcast media can
be used to intensify 'collective assemblages of enunciation'
– an idea originally formulated by Félix Guattari, and now
unfolding in diverse ways across the ubiquity of media.

The first books in this short series are:

Claire Fontaine, *Human Strike Has Already Begun & Other
Writings*, (ISBN 978-1-906496-88-3)

Clemens Apprich, Josephine Berry Slater, Anthony Iles and
Oliver Lerone Schulz (eds.), *Provocative Alloys: A Post-Media
Anthology*, (ISBN 978-1-906496-94-4)

Félix Stalder, *Digital Solidarity*, (ISBN 978-1-906496-92-0)

The PML Book series is just one of several outlets for the
Lab's exploration of post-media strategies and conditions,
which includes fellowships, a virtual lab structure,
multiple collaborations, events, group readings and other
documentation.

For more information see: www.postmedialab.org/publications

MUTE BOOKS

PML Books

The Post-Media Lab is part of the Lüneburg Innovation
Incubator, a major EU project within Leuphana University of
Lüneburg, financed by the European Regional Development
Fund and co-funded by the German federal state of
Lower Saxony.

CONTENTS

Introduction

On 20 October 2012, exactly four years after the crash of its banking system, 66 percent of voters in Iceland approved a new draft constitution. This was to constitute the crowning achievement of what began as a wave of spontaneous popular unrest. The kitchenware revolution, named after crowds banging pots and pans that showed up spontaneously in front of parliament, mobilised itself against a public bailout of banks and the implementation of orthodox austerity measures. But more than that, the people managed to oust the government and initiate reforms at a fundamental level aimed against such corruption and misappropriation ever happening again. The core element of these reforms was the new constitution.

The drafting of a new constitution generated a great deal of controversy.[1] The conservative parties which had enabled the financial boom and bust through deregulation, privatisation and cronyism argued, correctly from a legal standpoint, that the writing of constitutional law is the exclusive domain of the parliament. Yet crucially, the new constitution was written by a newly formed 'Constitutional Council' consisting of 25 elected citizens, acting as individuals not representing any party or group.[2] The council decided to involve the public at large which could, and did, participate through social media and a custom made website by proposing changes and making comments to proposed articles. But the resistance from the opposition was not just motivated by legalistic concerns, but also by the content of the constitution itself, which embodies a resounding rejection of the

neoliberal principles that these parties had championed while in office. The constitution is informed by three core concerns: distribution of power, transparency and responsibility. This is expressed already in the preamble of the constitution:

> We, who inhabit Iceland, want to create a fair society, where everyone is equal. Our different origins enriches all of us as a whole and together we have the responsibility for the legacy of the generations, land and history, nature, language and culture. [...] The government shall endeavour to strengthen the welfare of the country's inhabitants, encourage their culture and respect the diversity of the life of the people, the country and its biosphere.[3]

The fact that Iceland has been able to write a new constitution at all reflects its unique position as a still relatively sovereign country outside the European Union, its deep history of self-reliance and occupation of a relatively marginal position within the world economic system. This has provided the people of Iceland with the freedom to chart their own course after the financial collapse, in contrast to EU member states such as Ireland or Latvia, similarly hard hit by the financial crisis. However, almost one year later, the constitution has still not been approved by parliament and the newly re-elected conservative government shows no signs of putting it forward for ratification. Thus, the whole process has been left in limbo.[4]

Yet, the process of writing the constitution, which took place outside established institutions enabled an unprecedented degree of openness and participation by individuals (rather than by representatives).

Furthermore, the content of the constitution, which combines a recognition of diversity with a demand for equality, a reaffirmation of government as the collective agent of the people, and common responsibility for shared natural and cultural resources, reflects a new subjectivity, and is made possible by it, a new sense of solidarity that is not limited to Iceland or Europe, but can be seen to be struggling to emerge, in a wide variety of ways and forms, in many places around the world. In some respects Latin America is more advanced than Europe here. New forms of participation have been implemented in more than 30 thousand community councils in Venezuela, and in Bolivia significant innovation is developing from attempts to revive and update indigenous traditions of community self-organisation.

All of these events are indications that 50 years after Marshall McLuhan's naming of it, we have left the *Gutenberg Galaxy* for good.[5] That is, a comprehensive historical constellation dominated by a particular type of subjectivity which emerged from a highly specific but ubiquitous experience: reading printed material, alone and in silence. Through this act, a single person was to make sense of the world, and his or her position in it, by following a regular visual line of abstract symbols, assessing the acquired information through individual reasoning. This subjectivity, or as McLuhan called it, 'sense ratio', was strongly biased towards linearity and regularity on the one hand, and towards individualism on the other.[6] The first bias led, for example, to conceptualising space as 'uniform and continuous', time as an arrow pointing into the future, and to compartmentalise social life into distinct domains,

such as public and private, work and leisure. The second bias expressed itself, for example, as 'competitive individualism' and in the aesthetics of the central perspective, representing the visual experience of a single point of view. As McLuhan stressed, 'far from being a normal mode of human vision, three dimensional perspective is a conventionally acquired mode of seeing, as much acquired as is the means of recognising the letters of the alphabet, or of following chronological narrative.'[7] For McLuhan, this particular constellation could inform a wide range of political projects. Industrial capitalism and Soviet style communism were both seen as part of the Gutenberg Galaxy. Indeed, they had many elements in common, for example, both systems were based on assembly line organisation of work processes, and the entire social and cultural apparatus required to make this kind of organisation work.[8] The reason I mention this here is to bring into view long term historical constellations that relate a particular subjectivity to a wide range of cultural, social and political projects and institutions. The actual relationship between the two is highly contestable, and McLuhan has been criticised – correctly when read narrowly but unimaginative as an interpretation – for simplifying it to the point of technological determinism.[9]

Today, we are entering into a new constellation, a new galaxy, and the reformulation of solidarity in a myriad of ways, such as the new draft constitution in Iceland, may be one of its most hopeful vectors. There are many much less promising dynamics feeding the maelstrom as well. Some of these are very rapid, such as the destructive effects of all encompassing commodification and financialisation, others are slower but set to run for a

very long time, such as the reorganisation of geopolitics, resource depletion, or climate change. The consequences of any of these are not hopeful. It's hard to see anything good coming out of climate change, for example, despite the giddy prospects of opening up the Northwest Passage for shipping or of better access to natural resources in the thawing Arctic. The reorganisation of geopolitics is likely to make it very difficult to create an effective new framework for international co-operation in the foreseeable future. The confluence of all of these currents doesn't make things any better. At the moment, their most visible effect is the deep, yet uneven crisis of many political and economic systems around the globe, both in terms of their capacity to address urgent problems and of their legitimacy to represent their citizens. In what follows, I will focus on western experiences, simply because my knowledge is limited. Here, in particular, the crisis is also a cultural crisis because these countries have traditionally constituted the core of the Gutenberg Galaxy and are now facing a particularly steep learning curve as they try to adapt to the world outside of it.

In addition to this complex set of overlapping dynamics is one that is, indeed, more directly related to the media. At the core of the most advanced technological, scientific and cultural processes we can observe a growing tension between the social character of production and the private character of appropriation. Increasingly, productive processes are no longer contained within traditional economic units, such as private firms, but are diffused into society at large, embedded in complex webs of individuals, loosely organised groups, densely organised volunteer networks, foundations, firms, corporations, and public

institutions. In other words, the sites of production (i.e. the heterogeneous networks) are becoming separated from the sites of appropriation (i.e. private firms) and markets are becoming ever more globalised, yet fragmented and molecular in response. Following Karl Marx, one can see this as an intensification of the tension between the *forces of production*, that is, applied innovation and technological progress, and the *relations of production*, that is, the economic institutions which organise these forces. He put it this way:

> At a certain stage of development, the material productive forces of society come into conflict with the existing relations of production or – this merely expresses the same thing in legal terms – with the property relations within the framework of which they have operated hitherto. From forms of development of the productive forces these relations turn into their fetters. Then begins an era of social revolution.[10]

The difficulty lies, of course, in assessing when a 'certain stage' is reached in historical reality and significant theoretical efforts have been invested to identify and map 'long waves of technological change' or transformation of large scale 'techno-economic paradigms'.[11] Cultural critic Brian Holmes is transforming these attempts into a theory of three crises: 1930s, 1970s, and now.[12] But it remains very difficult to see whether this tension acts – as it does in normal times – as the engine of capitalist innovation (Joseph Schumpeter style), or, if it is already at the point where it harbours something deeper, a structural crisis of the system as such. Analysis and everyday experience suggest that we are not in normal times. But even so, it remains to be seen

if the crisis affects the entire system or just certain segments that might be reorganised through another mode of production, parallel to, or subsumed under, the capitalist mode. This is possible because, as David Graeber has argued, no system, even capitalism, is ever all encompassing.[13] There are always pockets and layers of reality that conform to different logics.

So, while the big picture remains murky as usual, certain things can be stated more clearly. Transformations of subjectivity and of social structures are animating contradictory social, cultural, and political realities. On the one hand, there are new institutional and cultural forms emerging to support such complex webs of interaction and production, often based on the notion of a shared resource, a commons, and focused on the particular requirements necessary to develop and protect that one resource. They offer a chance to remake society in a particular way, through reinventing social solidarity and democracy, be it in the digital networks of informational co-operation or in the common appropriation of physical spaces. On the other hand, attempts to privatise information and knowledge have been radicalised to a point where they not only threaten to undermine their own productive basis (shared knowledge and culture, access to education, freedom of research), but are also coming into direct conflict with the core principles of liberal democracy itself, such as freedom of speech, transparency of legislation and due process, presumption of innocence, or protection of privacy. Thus, it is crucial to distinguish between structural transformations and the diverse social or political dynamics shaped by them. Because, the same structural transformation can lead to entirely different

social realities depending on the political dynamics operating on them. Contradictions can be resolved, or tamed, in ways which can lead to an expansion of new freedoms, or to a hardening of existing exclusions. Often, both happen at the same time, yet to different social groups. We can see this in the ubiquitous rise of *liquid surveillance* techniques, which are equally suited to produce 'care' (in the form of personalised services) and seduction as much as control and repression.[14]

In this book, I will look at the new forms of solidarity which are emerging in the digital realm. I will draw up an inventory of forms, reduced to four basic types: commons, assemblies, swarms and weak networks. These four basic types exist in a bewildering variety of shapes and sizes. The social realities they produce are not congruent or necessarily peaceful. Solidarity can be mobilised towards all ends, good and bad. Yet, despite these differences, there are certain elements of a common culture running through them. A culture of digital solidarity can be described as one rooted in a lived practice of sharing. The Icelandic constitution, if ratified, would embody this culture. However, as Manuel Castells reminds us, a common thread does not ensure an overall peaceful processes, as the term 'sharing' might imply: 'the protocols of communication are not based on the sharing of culture but on the culture of sharing.'[15] I will begin by sketching some of the structural transformations which underlie the creation of digital solidarity.

Structural Transformations

We live in turbulent times, and the winds are blowing from all directions. We need to learn to distinguish them. There are several deep structural transformations that fuel the winds pushing forward the social character of production: the transformation of work, new subjectivities and the availability of new infrastructures. First, the character of work has been changing for the last 30 years. This is most visible in the most advanced sectors of the 'information economy' but not limited to there only. Work, most generally, is becoming more social, more communicative, more complex and more networked. Social skills, such as teamwork, identification and empathy, are becoming more central to work as an ever growing share of workplace tasks consists of communication and coordination. More and more time is devoted to checking on others, understanding where they are at and adapting plans accordingly. The more equal the relationships within teams are, the more explicit the experience that one cannot work against, or even without the others.[16] Doing it alone is not an option, not least since the complexity of the issues that are addressed has been rising steadily. The personal experience of the knowledge economy or knowledge society is, to a large degree, the experience of not-knowing, of not being able to solve a problem oneself. Nobody, even in the most narrow of specialisations, can think of him/herself as truly mastering the field, let alone all the neighbouring fields necessary to make one's own domain meaningful in some way. This is accentuated because complexity within each field is coupled with continuous changes, in the practice itself, but also in the way it is embedded

in larger contexts. As more social processes rely (or are made to rely) on software based infrastructures, the easier they can be reconfigured, and the more 'liquid' they become.[17] Capitalism needs flexibility, new technologies enable it more than ever. This is a self-reinforcing development, where accelerating flexibility is turned into an imperative, echoing Marx's famous 'coercive laws of competition'. This is even reflected in the built infrastructures that are increasingly becoming multi-functional. Data-centres – giant warehouses full of servers that provide much of the computing power for the public internet and for private corporate networks – being the most pronounced example. While they are, indeed, heavy built environments with very long term trajectories – located following the classic industrial logic of cheap energy and good (data) transportation links – nevertheless, they can support any process that can be embedded in software. To reconfigure a data centre to support a new web based application that reoganises an entire industry (say, the distribution of eBooks) is much easier than to build a new factory to produce a new product. Data centres consist mostly of highly standardised, commodity infrastructure, running globally interoperable protocols. Yet, on top of these, highly specific, proprietary services can be built. They are part of new globally distributed, standardised infrastructures, which also include supersized airports and shipping ports that produce flexibility, even if they themselves are not particularly flexible.

Thus the value of knowledge, particularly practical applied knowledge, is degrading constantly and expanding the experience of not-knowing correspondingly. The more the world is becoming interconnected, the more

we realise how important interconnections are, the more we realise we actually know less than we thought we knew. But this experience of not-knowing is tempered by the possibility of finding someone (or something) who possesses this particular piece of information, skill or knowledge that one is lacking. The famous *maxim* from free and open source software, 'given enough eyeballs, all bugs are shallow', expresses this experience succinctly. For every (technical) problem that appears intractable, there is someone, somewhere, to whom this particular problem is easy to solve. What is needed then are infrastructures that make it possible to locate and co-operate with this particular person. The larger the pool of potential collaborators is, the more ease with which these potential collaborators can access the resources in which the problem is embedded, and the more freely they can themselves benefit from the solution to which they might contribute their own scarce labour resource, the more likely it is that this process can take place. In relation to the ever expanding issues we are facing, one might say that each of us is becoming less intelligent individually, because individually we can understand their complexity less and less. Yet we are becoming more intelligent collectively because we are developing ways to connect partial understandings productively on a new scale.

The social, communicative, complex and networked dimensions of the production process are mutually reinforcing, thus creating dynamics that are so strong that they can break down existing organisational boundaries and expand into the social. Here exchange can take place unencumbered by traditional forms of ownership and the required accounting overheads

associated with tracking changes in ownership. Thus, production expands from the economy in the traditional sense to society at large. A new kind of public sphere – the sphere of social production – is emerging, even as the old public sphere – the sphere of democratic debate – is eroding.

Production, rather than being purely commercial (or public) is becoming social as well. That is, it comprises very heterogeneous actors, each pursuing their own goals, according to their own agenda and interests, but through a shared resource to which they contribute and from which they can take. This greatly expands the range of things that can be produced, since production no longer needs to be geared towards the markets and its orientation towards exchange values. Increasingly, production can be oriented towards use value. People producing together things they value for themselves. Thus, aspects of production take place outside the market in a co-operative manner, even if some outputs from this production can be re-translated back into the market and into relationships of competition. In a way, one could say that as the market encroaches on the social, the social encroaches on the market, blurring the boundaries between the two domains in ever more complex ways.

The idea of working in isolation, of doing things alone, is becoming completely impractical, to the degree that becoming disconnected is experienced as an existential threat. This reverses the source of freedom as it is conceptualised in the liberal notion of the private individual. There is reason to assume that we are in the process of reorganising subjectivity in such a way that the experience of being connected is becoming primary

and processes of individuation and of disconnection are being articulated in relation to this primary experience. This sharply differs from the previously dominant (liberal, bourgeois) conception of subjectivity that begins and ends in the private sphere.

This leads to the second big structural shift: the changing relationship between individuality and collectivity. To put it simply, the foundation of individuality is shifting from the private realm to the network. This is necessarily speculative, but there is some evidence that can guide such speculation. To better understand the ramifications of this seemingly small shift, we need to step back a bit. Since the 18th century, the liberal order had placed the individual at the centre alongside, and constituted, through the modern state. While the emphasis on individuality does not change, the very character of individuality is changing as is, inevitably, its relation to the state. In view of this, it is no coincidence that the rewriting of the Icelandic constitution took place outside the established framework of liberal democratic institutions. But let's focus on the constitution of individuality itself. Traditionally (i.e. in the liberal view) individuality was closely connected to the idea of privacy. Indeed, privacy was supposed to enable and protect the formation and authenticity of the individual from external forces.[18] This, as Marshall McLuhan proposed long ago, reflected the mode of encountering the world through private (silent) reading.[19] This idea of the private individual thus provided the foundation of all forms of modern democracy and vice versa. This is epitomised, for example, in the design of the voting both, where one person, separated from all others, can reason and act in complete

privacy and thus delegate and legitimise political power. This notion of privacy is so overwhelmingly important to this political order that it is rendered in the strongest possible form, as unconditional anonymity.

Based on this freedom through privacy, individuals could enter into relationships with one another on a free and equal basis. The entire concept of the social contract (be it Rousseauian or Hobbesian), or any other contract for that matter, relies on this notion of individual freedom as the basis of engaging with others. Thus, the relationship between the individual and society, or any form of collectivity, has always been seen as problematic, since in liberal theory such collectivities are viewed primarily from the perspective of how they might interfere with that basic freedom localised at the level of the individual person. In practice, this atomistic and radically individualistic notion has been tempered by two opposing political projects. The conservative view saw traditional collectivities and their particular social structures as the primary locus of the social, and was thus opposed to the corrosive effect of liberal individualism. The socialist view focused on the new forms of collectivity which were to be created in order to overcome historic divisions and structures.

The rise of neoliberalism from the mid-1970s, which developed in parallel with the demise of both the traditional conservative and socialist movements, radicalised this liberal distrust of the collective elements of society in new dimensions. Margaret Thatcher, famously, declared in 1987, 'you know, there is no such thing as society. There are individual men and women, and there are families. And no government can do anything except through people, and people must look

to themselves first.' Given the well known problems of bureaucratic organisations and the freedom the markets offer to those with the required means, this vision enjoyed a fair measure of popular support in the West in the last decades of the 20th century. Enough that fierce battles against collective organisations, most importantly unions and local governments, could be sustained politically. As a consequence of both the destruction of traditional working class milieus and the new experiences in post-industrial economies, an extremely individualistic view and faith in the market as enabling expanded freedoms was established as a form of 'common sense' consensus, not least by the social-democratic left which was now rebranding itself as 'new labour' or the 'third way.'[20]

This absorption of neoliberalism by the centre-left was possible because it was animated by some of the core values of the social movements of the 1960s: flexibility, creativity and expressiveness.[21] Severed from their political roots, they have spread throughout society. Today, they are regarded as generally desirable personal traits, necessary for social success and, increasingly, seen as corresponding with the 'true nature' of human beings. While the neoliberal vision is still politically operative, it's no longer a promise (that animated the Blair/Clinton project), but a dogma and coercive force.[22] This, however, has not affected the appeal of flexibility and individuality as social values. Rather, they are being freed from their neoliberal framing, developed further and connected to new political projects. Thus, they are in the process of finding new expression in forms of sociability that emerge on a mass scale, pioneered by internet-mediated communities. It is through these experiences that the

construction of contemporary individuality shifts from being rooted in the private realm to being based in networking.

Sociability in this new environment is starkly different from earlier forms. In order to create sociability in networked, communicative environments people first have to make themselves visible, that is, they have to create their (re)presentation through expressive acts of communication. Simply being present, passively, is not enough. In order to connect to such networks, a person also has to be suitably different, that is creative in some recognisable fashion, and abide by the social conventions that hold a particular network together. Thus, there is a particular type of individuality emerging. One must combine the expression of differences and the acceptance of certain types of conformity. This has to do with the character of digital social networks. In a context where information can be easily copied, networks gain value by connecting differences to one another, thus realising the promise that resources one does not possess can be found within the network. But these differences need to be of a certain kind; they need to respect, even actively reproduce the protocols, both technical and cultural, that make the connecting and exchanging of flows possible in the first place. Because networks are defined by protocols, that is, by 'rules of engagement' and a network extends as far as its protocols are shared.[23] In many ways, the best definition of the internet is 'anything that runs on TCP/IP', that is, the space built on top of a particular protocol.[24] Without the acceptance of the defining protocol(s), one cannot access a network and the resources it provides. Without accepting the rules of engagement, there cannot be any engagement.

There are both negative and positive drivers to making oneself visible in such a way: there is, on the one hand, the threat of being invisible, ignored and bypassed and the promise of creating a social network that really expresses one's own individuality, on the other. This creates a particular type of subjectivity that sociologists have come to call 'networked individualism'.[25] 'Individuals', Manuel Castells notes,

> do not withdraw into the isolation of virtual reality. On the contrary, they expand their sociability by using the wealth of communication networks at their disposal, but they do so selectively, constructing their cultural worlds in terms of their preferences and projects, and modifying it according to their personal interests and values.[26]

There are two important points here. First, people construct their individuality through sociability rather than through privacy, that is, through positioning themselves within communicative networks. Second, they do so in multiple networks and shift their allegiances over time across these networks and from old to new ones. Thus, individuality arises from the unique concurrences of collectivities within a particular person. Though this is, presumably, only visible to a small number of people who know a particular person in a traditional, holistic way. Individuality evolves over time – as a unique concurrence of collectivities that a person can actively hold – to reflect changing needs and desires.[27]

Since these collectives are networks of sociability – horizontal forms of organisation, based on self-selected, voluntary associations – they require some

degree of trust among the people involved. While trust deepens over the course of interaction, as it always does, there needs to be a minimum of trust in order to start interacting in the first place. Traditionally, establishing trust between strangers has been viewed as impossible, since they cannot rely on past behaviour or the prospect of future interactions. Under these conditions, game theory predicted non-cooperation.[28] In digital networks this problem has been solved in practice because of the easy availability of some kind of track record of interests and projects that each person creates by publishing (voluntarily and as an individual) information about him/herself; what he or she is interested in, passionate about, and investing time in. In other words, being expressive (about anything!) is the precondition of creating sociability over communication networks, which, in turn, comes to define people and their ability to create or participate in projects that reflect their personality.

This need to express one's desires and passions in order to enter into a sociability that creates one's identity slowly erodes the distinction between the inner and outer world, so central to the modern (liberal) notion of subjectivity, forged in the Gutenberg Galaxy.[29] Contemporary forms of subjectivity are based on interaction, rather than introspection. Privacy, in the networked context, entails less the possibility of retreating to the core of one's personality, to the true self, and more the danger of disconnection from a world in which sociability is tenuous and needs to be actively maintained all of the time because it is based on explicit acts of communication. Otherwise, the network simply reconfigures itself, depriving one of the

ability to develop one's individuality. Thus, networked individualism seems to be a form of subjectivity that can address, at the same time, two human needs that used to be thought of as mutually exclusive: the need for individual distinction as well as for social recognition and shared experiences.

The third layer of transformation concerns the infrastructures for individual and collective agency. Over the last decade, the infrastructures of digital co-operation have expanded, matured and been widely adopted. There are, of course, the major social networks, like Facebook and all the rest, that are now real mass media. For all their problems, to which I will return later, they are very powerful technologies explicitly focused on co-operation in groups, small and large. Importantly, they are readily available (technologically and culturally) and do not require investment in expensive organisational build up. But these are just the most popular, consumer oriented parts of a sprawling infrastructure of digital co-operation. Over the last few years, the infrastructure as a whole has become so differentiated that it enables co-operation in socially nuanced ways, ranging from closeknit trust circles to more or less complete anonymity. Depending on the type of co-operation intended, mainstream tools might be fully sufficient, but there are also more specialised tools, available on central servers, or those which can be installed in a decentralised way under full user control. An example for this are 'etherpads'. These are, as Wikipedia helpfully explains,

> web-based collaborative real-time editor(s), allowing authors
> to simultaneously edit a text document, and see all of the

participants' edits in real-time, with the ability to display each author's text in their own color. There is also a chat box in the sidebar to allow meta-communication.'[30]

There are several additional features that allow users to manage versions during the co-operative process of writing a text together and export the text at any point. Pads are limited in functionality, but very simple and easy to use. The initial software was created in late 2008, acquired by Google and released as open source software about one year later. Almost immediately, a number of providers sprung up that enabled anyone, without registering or installing software, to use this tool for their own purpose. Among the first was the Swedish Pirate Party which has been running this service ever since.[31] But this is relatively simple open source software, so it can be installed anywhere, and does not rely upon a central server that may or may not be trusted. The co-operation process can be made fully public, or password protected for confidentiality. Pads are now a mundane part of the technological infrastructure. They enable a particular type of co-operation – editing a text of short or medium length, in real time, by a small number of people. Since all versions of the etherpad have an export function, it is trivial to transfer the content into another part of the infrastructure if other types of cooperative processes need to be enacted.

The point of mentioning etherpads here is not because they are exceptional. On the contrary, they are symptomatic of the current infrastructure of co-operation that exists as a patchwork of tools, from the narrowly specialised standalone tools that support just one molecular act of co-operation, to integrated

platforms that support a wide range of complex interactions. The providers range from the corporate media of self-communication with mass user base, to hackers who run infrastructures for a much smaller groups of skilled users, which are largely beyond the control of third parties. The most spectacular examples are WikiLeaks and The Pirate Bay which are still operating despite years of persistent attempts to shut them down. Overall this patchwork infrastructure is extremely differentiated. While most people might use the commercial elements most of the time, they do not use these exclusively. It's not unusual to have an account on Facebook and on The Pirate Bay. Developers and skilled users can string different elements together as equired. This infrastructure enables not only new forms of informational co-operation, but also of financing (crowdfunding) and material production (shared tools, open hardware manufacturing, 3D printing). While the maintenance of infrastructural elements, with the associated requirements of availability and stability, is often a complex task in itself, the technical knowledge to do so is also fairly distributed, and since much of it is open source software, usually accessible to anyone with sufficient interest. By now, almost all large scale co-operative movements have their own technical working groups that configure and extend the infrastructure of co-operation, resource sharing, financing and, to a lesser extent, are also already manufacturing or customising these to their own needs.

The Social Laboratory

Over the last two decades, the internet has been a laboratory for social innovation. One of the most unexpected collective discoveries has been the existence of another mode of organisation to achieve large scale co-ordination. This mode relies neither on the market where price signals perform important co-ordinating functions horizontally (as Friedrich Hayek famously stated), nor on public and private bureaucracies where commands facilitate vertical co-ordination.[32] Rather, it relies on voluntary co-operation to enhance the use value of a shared resource. Yochai Benkler dubbed this mode 'commons-based peer production.'[33]

In the West, most areas of life beyond the personal realm have traditionally been organised as a mixture of markets and bureaucracies. Over the last 30 years, however, the balance has shifted decisively towards market based mechanisms. Not only are ever more areas of life now organised as markets, even (public and private) bureaucracies themselves are being de-aggregated and turned into semi-independent units (for example, into 'profit centres') that compete against each other and flexibly network with other semi-independent units inside and outside their own organisational frame.[34] Furthermore, the consumer – a single person buying goods and services in a marketplace offering choice – has become the dominant role and model of (inter)action, virtually replacing other models such as citizen or worker. More and more aspects of our life have become framed as choices in competitive marketplaces. Markets have expanded outwards and inwards.

While this has been the dominant story of the last 30 years, we are now observing areas where the market is retreating. Not in favour of bureaucracies and command structures, but of commons. There is evidently no market anymore for a general interest encyclopaedia, even though there is more demand than ever for general level summary information on a wide range of topics. To provide such encyclopaedic information, very significant resources, financial and intellectual, are still required. Yet these are no longer organised by way of commodity exchange in the market, but through social production in the commons.[35] The same development can be observed in other sectors as well, even if the picture becomes more muddled. It has been estimated, in 2008, that free and open source software replaced around €60 billion in investment in proprietary software.[36] This figure has probably increased since and is likely to be considerably higher than what free and open source software generated in new market transactions, though it is extremely hard to measure. Michael Bauwens has recently concluded, nevertheless, that free and open source software 'destroys more proprietary software value than it replaces. Even as it creates an explosion of use value, its monetary value decreases.'[37] As a general assessment of the economic transformation of free software, this seems justifiable.

The laboratory of the internet provides new foundations for experiences of co-operation, and open source is the leading metaphor. I understand co-operation here in a purely structural sense, as working together voluntarily for mutual benefit, no matter what this benefit might be. To be sure, the benefits can be quite destructive. The war in Iraq, for example, has been described as an 'open source insurgency', that is,

an organizational method by which a large collection of small, violent, superempowered groups can work together to take on much larger foes (usually hierarchies). [...] It enables: high rates of innovation, increased survivability among the participant groups, and more frequent attacks and an ability to swarm targets.[38]

The mutual benefits here are improved knowledge about more efficient ways to kill one's adversaries.

So while not all forms of co-operation need to beneficial to society at large, the structural experience of co-operation is a key element in the political project of strengthening social solidarity. This solidarity is more than an empty slogan, it is grounded in concrete, everyday experiences, renewed through collective action and guided by the conviction that one's own personal goals and aspirations cannot be achieved against others, but with and through them. Such solidarity, embedded in new narratives and creating new shared horizons for action, can provide the basis for novel cultural, economic and political forms. It isn't restricted to the internet. The same dynamic can help to reevaluate very old forms of organisation based on commons that existed in parallel to the dominant modes of prices and commands, since pre-modern times, but were often regarded simply as leftovers, as areas where modernity never bothered to show up, or simply ignored by the mainstream theories because they did not fit into any of the dominant theortical narratives centring around the capitalism/socialism divide. Commons are not capitalist, but also not anti-capitalist. They are, first and foremost, a-capitalist. A tenuous position.

Forms of Solidarity

The most comprehensive new formations for organising solidarity are developed through the renewal of the idea and practice of the *commons* or *commoning*. These are organised, long term processes by which a group of people manages a physical or informational resource for joint use. However, this is not the only form that can be distinguished in an admittedly schematic inventory of forms. Besides the commons, there are: *assemblies*, non-hierarchical, usually physical gatherings focused on consensus-based decision making; *swarms*, ad hoc, self-steering collective actors; and *weak networks*, groups constituted by extensive, yet casual and limited social interaction.

There are certain cultural threads that can hold these different forms together and make the movement of peoples and ideas from one form to the other effortless. I will return to those later. For now, I want to highlight the differences between them in ideal-typical fashion rather than through individual case studies.[39] This is not to imply that empirical settings do not exhibit hybrid forms, or that they do not change over time. But it's nevertheless worth distinguishing between them in order to highlight the variety of potentials they might embody.

Commons

Commons are long-term social and material processes. They cannot be created overnight and in order to become meaningful, they must exist over an extensive period of time. That means that they require some kind of

institutional framework that is both durable and flexible enough to meet changing demands and circumstances. There is no single model for institutions of the commons. On the contrary, it is one of their characteristics that they are sensitive to the particulars of the resource held in common and the composition of the group that manages this resource for its use value, and the general context in which the commons exist. Consequently, Elinor Ostrom (1933-2012), the leading scholar on the commons, explicitly avoided building an institutional model of the commons. Rather, she identified a number 'design principles', or general characteristics, that underlie what she called 'long-enduring common-pool resource institutions'.[40] According to her influential account, commons usually define and limit membership in the group that holds and manages the resource. This is more important in cases of physical commons, where there is danger of the resource being overused (the infamous 'tragedy of the commons'), than in 'non-rivalrous' digital resources which cannot be depleted. But, even in the latter case, there are usually conditions one needs to meet before being able to access the resource, such as accepting a free licence or adhering to community rules. Inside the group, there is often a kind of hierarchy based on a meritocratic principle, meaning that those who contribute more to the commons can usually use more of the resource (in the case of physical commons), or have a greater say over its development (in case of digital resources). In the case of digital commons, the meritocratic element helps to address the fact that the main challenge is not overuse but under provision. Making sure that those who contribute most can determine the course of development helps to keep this

crucial group of people inside the commons, which is valuable for everyone, thus their authority is usually not contested. Among the most important characteristics of commons is that they have some mechanisms for decisionmaking which involve the members of the commons in a comprehensive way. This is the essential element of self-government: the establishment of the rules which govern the commons by the people in the commons. This goes far beyond simply making a choice among options determined by outside parties. Commons are not marketplaces without money. The relevant choices to be made here are collective not individual ones. Since establishing and maintaining rules is never a friction free process, Ostrom points to the need to monitor compliance from within the commons and establish a system of graduated sanction, so that small violations can be sanctioned lightly, whereas substantial violations can trigger substantial consequences that can go as far as the expulsion of a person from the commons. Of course, inside the commons there are also conflicts that cannot easily be resolved by adherence to rules, so mechanisms of conflict resolution are required. Many of the problems within Wikipedia, for example, can be related to the fact that there is no functional way to resolve conflicts. They are often simply resolved by the fact that one party is more enduring than the other, or through decisions, such as banning certain contributors, that can appear extremely arbitrary.

Finally, no commons exist in a social void. They are always part of larger social systems which are usually oriented towards market exchanges or state control and thus are often hostile towards commons practices. Already simple recognition of the rights of the people

to manage a resource as a commons and regulate their own affairs is politically contentious. But without it, the commons remains very vulnerable to expropriation from third parties. This is most problematic in the context of indigenous commons and the pressure to privatise resources.

Ostrom highlights that commons are untouched by markets or states, but remain a means to engage and confront them and to force them to operate, or at least regulate, differently. The neo-anarchist approaches currently popular on the left are thus short sighted. Their power lies in pointing out the need to develop functioning alternative institutions, but they are unable to articulate a strategy of how to engage with the state, and how to inscribe new agendas and new orientations into state institutions. Stefan Meretz, for example, summarising 10 years of debates within the Oekonux project claims that 'commons-based peer production does not require to articulate people's needs in the form of opposing interests and thus is beyond politics.'[41] If one understands politics as the mediation of opposing (class) interests and if one looks only at the social dynamics inside the commons, this might be correct. But it is an entirely inadequate way to frame the relationship between a commons and its wider environment. The state and its coercive laws create highly differentiated sets of possibilities, reflecting strong market oriented interests, interests which won't disappear by simply ignoring them.

This problem is, perhaps, related to an unfortunate blindspot in existing commons research. Very little attention has been placed upon the relationship between commons and the wider social context, namely, state

and markets. Elinor Ostrom, for example, only studied commons that have emerged organically from the bottom up. Thus, questions of context and embedding were already somehow solved (otherwise the commons would not have existed in the first place). But today since we are confronted with a neoliberal downsizing strategy that has opportunistically seized upon the concept of the communal self-reliance, named *big society* in the UK or *resilient communities* in the the US, it is important to add two more 'design principles': *adequacy of resources* and a *shared cultural horizon*. The first means that within the community the material resources to organise a commons should be available. It is cynical to demand self-organisation from communities where the preconditions to do so are not available. So, in cases where the resources are not adequate to begin the process of commoning, one needs to ask how state and markets need to be transformed in order for resources to become adequately available to the commons. This, again, points to the need to engage with the state more explicitly.

But not only do material resources need to be available, there also needs to be something like a shared cultural horizon against which trust can be deepened and decision making becomes possible. Without a rough but shared understanding of the nature of the problem and of desirable solutions no commons will ever be created. The necessity of the latter two conditions – which are usually taken for granted in the commons literature that focus on commons that already exist – may help to explain why it is so difficult to create new commons on a larger scale, despite the growing interest in the concept from NGOs and an explosion of activism

creating new small scale commons, some physical and local (e.g. community gardens) others informational and distributed online.[42]

Assemblies

It is always difficult to build long term institutional structures. But often, this is not necessary, at least not in the beginning. On a somewhat shorter timescale *assemblies* provide a part of, if not *the*, social core of the current wave of protests that began in the Mediterranean in late 2010, reached the US at Occupy Wall Street in September 2011, and flared up again in Turkey and Brazil in June 2013. Assemblies are usually physical gatherings. This requires access to a suitably large, open meeting space. That space has often been created through the occupation of squares, parks and other public spaces. These occupations operate on a symbolic and pragmatic level at the same time. They are as much about re-appropritating public spaces at the heart of the city, as they are about creating spaces of shared experiences and collective deliberation, thus translating and extending the networked experience of shared, autonomous communication and community-building back into physical space.

Assemblies are based on a tradition of participatory democracy, but they are also developed in opposition to what is seen as the shortcomings of direct democracy, such as an overreliance on voting and an orientation towards majorities. In contrast, assemblies rarely vote. They are oriented towards consensus while, at the same time, allowing for the greatest multiplicity of voices. At times deliberate measures are taken to enable this

diversity against the tendency of the most forceful or organised groups to dominate open and relatively unstructured discussions. One way has been to adopt a culture of instant feedback through hand signals, turning passive listeners into active commentators without interrupting the flow of the single voice whose turn it is to speak. A more radical expression of the same idea is the so called 'human mic', by which the audience repeats and therefore amplifies the voice of the speaker. Initially developed to overcome regulatory restrictions banning loudspeakers from Zuccotti Park, the local focal point of the Occupy Wall Street movement, it has turned into much more. It not only allows a single speaker without technical equipment to address a larger crowd, but also avoids the problem that positions of authority become established through technology. Speaking and listening comes into a new relation as both become weak yet active. Also, the Occupy Wall Street assemblies used, as a method to increase diversity, the *progressive stack*. A stack is simply the list of people signed up to take a turn to speak. It's the main way to organise the flows of speakers in the assembly. To avoid this list being filled with people who are usually encouraged to speak in public (say, white, educated men speaking in their native language), the stack ranks speakers from marginalised groups (say, women, people of colour, non-heterosexuals) higher in the list. This has deeply affected the character and self-understanding of the movement. As the first declaration was being prepared by Occupy Wall Street, the initial draft opened with the following line:

> As one people, formerly divided by the color of our skin, gender, sexual orientation, religion, or lack thereof, political

> party and cultural background, we acknowledge the reality:
> that there is only one race, the human race.

This was quickly called out as a problematic papering over existing divisions – even within the movement. After a contentious debate that was shaped, among others, by a group of people who nicknamed themselves 'POCcupiers', (People Of Color) a different wording was adopted.[43] The final declaration, adopted on September 29, 2011, reads: 'As one people, united, we acknowledge the reality: that the future of the human race requires the co-operation of its members.'[44]

Even though assemblies can be a cumbersome process and the case of the wording of the declaration shows that, for all its strengths, the need to build consensus can lead to weak solutions – divisions are not spelled out but only indirectly acknowledged as diversity ('members of the human race') – they have been crucial to the entire process, and the building of real solidarity that underlies it. For David Graeber, for example, it was this radically utopian and immediately practical break with the established institutional forms of protest and resistance, and the resulting refusal to engage in the standard modes of interaction with the dominant powers (by way of demands and delegates), that allowed to movement to spread so quickly and deeply. Whereas other, more conventional attempts to organise against the crisis did not gain much traction.[45] The leaderless structures of assemblies, the ease with which people shift between roles of speaker and listener, the way in which discussions are archived publicly (if they take place online) or minutes are taken and made available publicly, reflect a by now widely shared internet

culture of transparency and flexible participation. It is no coincidence that the last of the eight principles of solidarity, articulated through consensus by the New York General Assembly takes up the quintessential hacker demand: 'making technologies, knowledge, and culture open to all to freely access, create, modify, and distribute.'[46] The ease by which experiences and debates are shared and condensed, and by which the learning of one group can be made available to others, locally and globally, helps to expand the potential of assemblies beyond spaces of experience to ways of pragmatic organising.

Commons and assemblies share, most notably, a focus on rough consensus, rather than majorities, and consequently a reluctance towards voting which usually serves as a means to produce majorities. In relation to commons, Ostrom explains this reluctance the following way:

> substituting a simple majority vote for a series of long discussions and extensive efforts to come close to a consensus before making decisions that commit a self-governing community, may lead to those in leadership positions simply arranging agendas so that they win in the short run. But as soon as rules are seen as being imposed by a majority vote rather than being generally agreed upon, the costs of monitoring and enforcement are much higher. The group has lost quasi-voluntary compliance and must invest more heavily in enforcement to gain compliance.[47]

Thus, what might be efficient in the short term could be corrosive in the long term. Thus it is no coincidence that assemblies, rather than simple voting procedures, play

a key role in the governing of many physical commons. In digital commons, there is also a general rejection of voting as a means of decision making. The principles of the hacker culture, which informed much of the early internet, are deeply inscribed in its technological infrastructure, and still shape the free and open source software world, were summarised by Arthur D. Clarke, then at the Internet Engineering Task Force (IETF), in 1992, when he famously declared: 'we reject: kings, presidents and voting. We believe in: rough consensus and running code.'[48] Majorities are not a good way to run voluntary associations, since they always run the danger of alienating the minority. In the case of online projects, it is very easy to leave and reconvene somewhere else. Hence, the rejection of voting in online communities is not related to the increased cost of monitoring compliance, but to the danger of the defection of contributors. Thus, there is a strong incentive for all participants to reach some form of consensus that ensures that the maximum number of contributors remain in the project.[49] Only in extreme cases where this is not possible, despite lengthy discussion processes, do splits in the community ('forking') indeed occur.[50]

Swarms

If the constant threat of decomposition lurking in the background is what keeps online communities committed to the complex task of establishing 'rough consensus', then it is continuous oscillation between centripetal and centrifugal dynamics that lies at the very heart of the third new form: swarms. A contemporary social swarm consists of independent individuals who

are using simple tools and rules to coordinate themselves horizontally to pursue a collective effort. 'Anonymous' is probably the most spectacular case of digital swarming, but it lies at the heart of most stories about how the internet enables spontaneous collective action through forms of 'organising without organisation'.[51]

It is this collective effort, defined explicitly and pursued consciously by the participants themselves, that differentiates these swarms from other forms of emergent mass behaviour which have fascinated and frightened theorists of mass politics since Gustave Le Bon (1841-1931). Thus, a contemporary swarm is a coordinated mass of autonomous, self-conscious individuals. They do not, as Le Bon and his followers ever since have suggested, substitute their conscious activity as individuals (reason) for the unconscious action as a crowd (emotions).[52] Rather, they constitute a self-directed, conscious actor, not a manipulated unconscious one. One reason for this is that these new swarms are joined consciously one by one, rather than arising out of preexisting crowds of people, and that they are maintained through explicit acts of horizontal, autonomous communication. It is misleading to continue to treat the two states of aggregation – collective and individual – as dichotomous, even when claiming that swarms such as Anonymous do not represent the 'end of subjectivity'. Instead, what arises is a new form of collective subjectivity without individual identity.'[53]

This is the outside view that only sees the mask. Seen from the inside, this look very different. As Rick Falkvinge, the founder of the Swedish Pirate Party, pointed out:

the complexity comes with the meritocracy that makes up how the Swarm operates and decides on courses of action as an organism. As all the people in the Swarm are volunteers – they are there because they think the Swarm can be a vehicle for change in an area they care about – the only way to lead is by inspiring others through action.[54]

Thus, the strength of the swarm comes from the number of individuals who join it and the focus it brings to their distributed, independent efforts. All swarms always start in the same way: a call for action and the availability of some resources to start acting right away. Social media researcher Clay Shirky identified three main requirements that must come together for such loosely organised cooperation to emerge: promise, tool, and bargain.[55] The promise is the call for action. It need not only to be relevant to a critical number of people but also credibly attainable. The tools are the resources and strategies available to work towards the promise. Today, tools to co-ordinate the efforts of volunteers are readily available online and different tools, such as online forums, wikis or chats, are capable of sustaining different social dynamics on all scales. The 'bargain' points to conditions one has to accept when entering the collective space of action. Only when the three dimensions match for a large number of people – the promise being attractive, the tools available, and the bargain not too onerous – does co-operation get underway. Over time, each of the three dimensions can change, and the swarm can grow, change direction or fall apart. For such swarms to be more than random and shortlived affairs, there needs to a fourth element, a common horizon, which, as cultural critic Brian Holmes

explains, 'allows the scattered members of a network to recognise each other as existing within a shared referential and imaginary universe.'[56] It is through this common horizon that we can also differentiate politically between different swarms. While all swarms are based on some acts of social solidarity, it does not mean that they are always socially beneficial. I'll return to this point later on.

Weak Networks

Quantitatively speaking, weak networks – groups held together by casual and limited social interaction – are the most important of the new social forms. They are often created by using technologies labelled as 'social web', or 'web 2.0'. These labels are unfortunate, because the important parts are not the technologies but the social formations and cultures that are built by using them. Due to their immense popularity, weak networks are setting a new baseline of what (inter)personal communication means today and they shape the new 'common sense' about social interaction. They are the new normal. Aggregated users and their actions are measured in the billions, Facebook alone announced 1 billion active users in October 2012.[57] By the end of that year, between one third and a full half of the population in developed and many developing countries have been using social networks regularly. A large number of them have indicated that they are using these networks not just to share information about personal or 'community issues', but also to share information about 'political issues', meaning they are both a means to organise one's personal life as well as a means to engage with the world

at large and to remake the world according this changed baseline of personal experience.[58]

Despite the size of these social networks, and the very considerable resources and influence of the companies that own the related network infrastructures, I want to call them 'weak networks' to highlight two aspects. First, these platforms excel at initiating and maintaining a large number of sporadic, limited interactions. These create what Marc Granovetter, over 40 years ago, named 'weak ties'.[59] Most people would agree that being a 'Facebook friend' with someone means very little compared to a conventional, intimate friendship. This, of course, does not mean that an intimate friend cannot also be a Facebook friend, but that strong relationships tend to be built outside of Facebook and the latter is merely a small strand within this. But 'weak' in this sense does not mean without consequence. On the contrary, Granovetter, in his foundational paper on network sociology, showed that it is precisely the information shared through 'weak ties' that helps people to orient themselves in the larger society they live in. The reason being that people who share strong ties share a lot of knowledge about the same (small) aspects of society they know very well. Hence there is very little new information to be shared between them, but the information that is shared is very rich in meaning. Strong ties produce closely meshed, enduring groups, for the better or worse. The number of strong ties a person can maintain is usually very small, hence these groups tend to be small. Weak ties, on the other hand, allow the accommodatation of lots of difference, because the areas of shared understanding and knowledge are, by definition, limited. Hence a lot of new information

can pass through these connections, simply because the differences between the two parties connected can be significant and the number of weak ties a person possesses can be very large.

One of the most important functions of weak ties is to connect closely meshed groups to one another and thus allow information to spread across a wider social range. They create 'small worlds' insofar as they create structural conditions to share information efficiently across large social distances. The famous six degrees of separation example, first imagined by Hungarian playwright Frigyes Karinthy in a short story entitled 'Chain Links' (1929) and first empirically tested by Stanley Milgram in 1967, illustrates this very well.[60] Seen from the point of view of network topology, it is assumed that two random people are connected to each other by an average of six nodes, these are six intermediary connections. This is a small number and cause of concern for epidemiologists. In social experience, however, a friend of a friend of a friend (two degrees of separation) is already a perfect stranger. This number, of course, is not a static natural phenomenon, but a function of network topology. Thus it is not surprising that within highly connected networks, this number is decreasing as the degree of connectivity is rising. Facebook announced in late 2011, that 'as Facebook has grown over the years, representing an ever larger fraction of the global population, it has become steadily more connected. The average distance in 2008 was 5.28 hops, while now it is 4.74.'[61] The 'price', of course, is that social meaning of what counts as a 'friend' has decreased so that by now, a Facebook friend of a Facebook friend, is – on a conventional social level – a stranger. Yet it is precisely a sense of connectedness

to 'quasi-strangers' that Facebook produces, and this is what allows weak networks to spread and what enables people to experience the world differently.

The intriguing suggestion made by Granovetter was that the study of weak links offered a perspective to address one of the vexing problems of social theory, the connection between micro-level interactions and macro-level events. It is through weak ties, he argued, that information travels across society at large and thus creates certain types of informal macro-level coordination.[62] This has nothing to do with digital networks per se, but the new technologies of connection make it possible to maintain a great number of weak ties very efficiently. Managing very extensive networks used to be a privilege of the elites who commanded a very expensive infrastructure for this purpose which included international meetings, conferences, clubs and support staff. Quantitatively speaking, this has been democratised. One no longer needs a personal secretary to remember the birthdays of 500 people. This has created many more small worlds (large but densely connected clusters), it has thus made the world as a whole much smaller, and affects the many ways micro-level interactions create macro-level events and vice-versa.

At the same time, it may well be that these 'small worlds' are again becoming more isolated from one another by way of the 'filter bubble'.[63] The filter bubble is the effect of new algorithms that try to personalise the information flows by privileging information travelling over certain types of channel. In principle, they are favouring information coming through strong rather than weak ties, because strong ties indicate

relevance. Yet, in practice, there are numerous signs that commercial communication is being privileged over non-commercial. Increasingly, commercial messages ('promoted posts' as Facebook calls them) are required to pass through the filtering algorithms.[64] This would suggest that weak networks do integrate and fracture the social world at the same time, creating a deeply integrated, yet highly non-linear, social geography.

The presence of the new filtering algorithms highlights the second reason why it is useful to think of social networks as *weak networks*: the very limited degree of control users have over the tools through which they build their networks and thus over the types of social relationships they can build. While there is no direct, determining relationship between a tool and the social dynamics it can enable, tools and their particular, often subtle, designs do matter. This is particularly important in the case of the current crop of tools for creating and maintaining weak networks which are constructed for a dual purpose. One purpose is that of attracting users to share information with other people. In order to be successful, these tools need to offer something that is really useful to people. People are not duped into creating weak networks and they would stop using them if they did not offer tangible benefits. The ability to share information and build extensive social networks is of great, immediate value to most people. Yet, these tool are, of course, equally – arguably even primarily – constructed to create profits for investors who financed it and thus shaped it from the beginning. As such, these tools enable the transformation of social value (created between users) into commercial value (created by and on behalf of the owners of the platforms).

At the heart of most digital social networks lies a tension between the horizontal exchanges through the users' weak ties to each other, and the vertical architecture of the platforms themselves. This techno-structural element in itself is not necessarily problematic. It could be seen simply as another instance of the typical layering of network architecture that often combines decentralisation of one layer with centralisation of another, making discussion of whether 'the internet' is a centralised or decentralised technology meaningless. Indeed, Wikipedia is an example where decentralised elements (the editing of individual articles, different language versions etc.) and centralised elements (the server infrastructure, the foundation) co-exist productively. However, Wikipedia is better characterised as a commons in which the contributors exercise a large measure of control over the institutional framework of their cooperation which doesn't serve any other purpose than to support their efforts.

In most weak networks, on the contrary, the tension arises from the deliberate congruence between two architectural designs (horizontal for the users, vertical for the owners of the infrastructure) and two value orientations (social value for users, commercial value the owners). During, the first half-decade of the existence of most of these platforms, roughly between 2005 and 2010, this tension was barely noticeable, since the social took precedence over commercial values. In these years, the main goal of such platforms was to attract users. Business models were not yet implemented. Most of these services did not generate profits and investors were willing to delay short term returns in hope of even bigger returns further down the line. This has

changed since all these platforms were either acquired by publicly traded companies or have become publicly traded themselves. Now the tension has become much more visible. In just a single week towards the end of the 2012, Facebook, for example, announced that it would grant itself an unlimited licence to commercially exploit content generated by the users of one of its subsidiaries (the photo-sharing service Instagram). The intention to commercially appropriate material produced for its social value was so overwhelmingly obvious that users revolted almost immediately. To avert a public relations disaster, the changes in the terms of use were cancelled, but it was made clear that the service 'was created to become a business. Advertising is one of many ways that [it] can become a self-sustaining business, but not the only one.'[65] Whether this amounts to an apology or a threat is probably besides the point, but simply states a basic fact very clearly: what is social interaction for some, is a business for others.

To capture this tension Tiziana Terranova coined the term 'free labour', which she situates at

> the moment where this knowledgeable consumption of culture is translated into productive activities that are pleasurably embraced and at the same time often shamelessly exploited.[66]

In contrast to phenomena such as crowdsourcing – where a large number of independent would be contractors are made to compete against each others for short term work – the transformation of value within and through social networks, does not easily fit the model of exploitation as proposed by labour theory.[67]

What is created here are not new sweatshops but rather new pastures from which to extract rent. As Steffen Boehm explains:

> In controlling social networking sites, companies like Facebook are able to charge a rent for access. This is not a direct rent [...] because Facebook is free to use. Rather, the rent is extracted as a tithe [...] so that, whilst consuming (freely) on Facebook, the user is simultaneously working (freely) for Facebook, producing themselves and their friends as audience and producing data that Facebook can commodify and sell. [....] Facebook does not reap a profit merely from organizing the paid labour of its relatively few employees [...], but extracts a rent from the commons produced by the free labour of its users.[68]

But this capture of the social process is not all. Increasingly, there is also direct rent. The ability to extract such rent, as David Harvey explains,

> arises because social actors can realize an enhanced income stream over an extended time by virtue of their exclusive control over some directly or indirectly tradable item which is in some crucial respects unique and non-replicable.[69]

In the case of Facebook and others, this 'tradable item' is the weak social ties. The aforementioned tendency towards 'promoted posts' is perhaps the clearest indication for the extraction of direct rent, being rather similar to the ability of the owner, of say a bridge, to extract rent by setting up a toll both. The list of attempts to extract rent is near endless as the demands of investors to realise returns, either directly or through the rise of stock prices.

If this tension spells doom for social networks – imploding as users feel alienated by the commercialisation of their social spaces – or, if this represents a sustainable extension of the commercial logic even deeper into the social fabric remains to be seen. For now, they contribute to establishing co-operation and sharing, in some limited, possibly distorted way, as a normal social experience within a society otherwise dominated by competition and atomisation in the markets.

Culture of Solidarity

Across these new social forms, even if they not only differ from one another as ideal types but that each of them exists in a near infinity of concrete shapes, sizes and flavours, there is something like a common culture emerging: a culture of autonomy and solidarity. Autonomy can be defined

> as the capacity of a social actor to become a subject by defining its actions around projects constructed independent of the institutions of society, according to the values and interests of the social actor.[70]

In the present context, the social actors creating new spaces for autonomy, as we have seen, are collective or, better, connective ones, utilising the capacity of digital networks to coordinate people horizontally. Sociologically speaking, the people that make up these actors tend to be educated, often young and competent in their use of digital media, yet alienated from

established institutions that are ever further plunged into an extended crisis of legitimation.

Digital networks are an essential element in the contemporary reconstitution of autonomy and solidarity, even as their empirical presence and importance varies from case to case. Hence, it is no coincidence that many of the values that have been embedded in digital technologies are prominent in this new culture and this contributes to a revival of autonomist approaches. The relationship between network technology and autonomist movements is a complex one. Many of the (North American) pioneers of these technologies were deeply influenced by the decidedly non-technological experiences of the 1960s counter culture and developed technological systems as a way to advance these values.[71] Today, the practice of digital networking is a core element in their reconfiguration. The result, of course, is not a virtual culture but a hybrid one, where the experience of digital communication is carried into all kinds of social institutions and practices, up to and including the reorganisation of physical space. All of this is driven by the ever changing desires of social actors.

The autonomous culture of solidarity is characterised by core values that exist across diverse settings – even if the articulated agendas can be antagonistic. Manuel Castells summarised these values as 'trust, tolerance and togetherness'.[72] It might be useful to unpack them somewhat further as sharing, co-operation, individuality, participation and diversity. Let's start with the last one. In networks, diversity is being articulated both on a micro- and on a marco-level. On a micro-level it concerns the identity of the singular person. The practice of networking allows each person to be present in different

social contexts at the same time and to express their own personality through the unique combination of these contexts embodied in their own life. Each of these contexts is partial and none encompasses the whole of the person completely. Thus, the identity of people is expressed less as an essentialist in-dividuality but rather as a relational singularity.[73] This allows for a greater diversity of roles and identities of each person, but also a greater degree of freedom and flexibility towards each of them. Yet, this amounts neither to a multiple personality disorder nor to a free play of compartmentalised identities as early internet theory assumed.[74] Instead, a patchworked identity in which the different patches can evolve according to different rhythms following the less and less standardised biographies of people. This multiplicity on an individual level leads to a greater capacity for diversity on the macro-level of the collective or social movement. The new social forms are not expressions of unified life projects, rather they are ways to act in the world with varying horizons. And thus, what they require are not comprehensive ideologies and commitments, but pragmatic experimentation with finding and developing ways to act within situations and advance the desires animating each of them.

An active support of diversity serves both a desire to overcome isolation and rebuild the social. It also serves as strategy for increasing the field of experimentation and learning, and breaking through the boundaries of an obsolete cultural landscape. The greater diversity within these new forms of solidarity is enabled by the expanded communicative capacity of digital networks through which they coordinate themselves. There is little need to restrict expression. It can take place

unrestricted on a wide range of platforms, media and settings. The ability to search, filter, and extract – by technical and social means – from all of these sources allows the collective actors to absorb whatever is relevant to their constituents and ignore the rest without suppressing their expression and thus leaves it available for possible future consideration. There are, for example, an unknown, perhaps an unknowable, number of Twitter accounts for the many swarms that make up Anonymous. Many of them, it seems, are run by ignorant teenagers and attention seekers, making outlandish claims such as bringing down Facebook. While the mainstream media like to report things such as this, these calls generate no traction at all among possible contributors. However, this doesn't affect the reputation or ability to act for other swarms that are Anonymous, because the filtering happens after the fact of publication and takes place in a decentralised way. On a personal level, everyone needs to decide which of the many accounts to follow; a decentralised process through which some gather prominence and others do not. The same processes applies when each follower decides how to relate, or not relate, to a message he or she receives. The importance of any pronouncement lies not in the person making it, or even in the content of the message itself, but in the reaction it manages to generate. This makes it very difficult, if not impossible, to represent these new forms through traditional leader figures.

Indeed, the new forms of solidarity are about participation and not about representation. This does not mean that there is no leadership at all, but leadership emerges from the ability to attract followers, participants,

contributors, and dissolves as this ability wanes. It's not leadership as representation and as central position, but leadership as the inspiration to act autonomously and in the facilitation and coordination of such actions.[75] Indeed, a recurring theme is the leaderlessness within these new formations. Hierarchical command structures are rejected in favour of multiple, overlapping frameworks of horizontal participation oriented towards partial goals and structured by a flexible meritocracy whereby what counts as a 'merit' in each particular context is open to negotiation. The practice of the progressive stack and the meritocracy it produces, for example, is the outcome of such complex negotiations.

Even if participation and cooperation is central to the culture of solidarity, equally central is a strong sense of individuality, or singularity of each of the participants. The tension between collectivity and individuality is, if not completely resolved presently, at least less of a problematic issue than it has been throughout the 20th century. Digital networking enables, probably even demands, the connection of differences with one another (as already mentioned) while enabling the near infinite and automatic replication of sameness. New modes of visibility have made it easily possible to move from crowds to single people and back. The trade-off: scale and detail no longer exist since zooming in and out has become standard. The scale can be adjusted to the level of detail necessary for a particular purpose, and not just on maps. Just as we can smoothly scale from a view of the earth as a whole to a view from streetlevel, we can move from reading a Wikipedia article as a single coherent text to following the intricate changes that numerous people have made to it over a prolonged period

of time. This also relates to the relationship between the single person and the collective which are increasingly understood as poles on a sliding scale. Singularity is a precondition of becoming visible in networks and being part of a larger network is a precondition of developing particular aspects of one's person. Insisting on privacy, in this context, is unsuccessful as a strategy to protect the core of individuality and carries the danger of making a person invisible, thus leading to self-selection and self-exclusion.

The new interdependence of singularity and collectivity is particularly visible in free software projects, where intense co-operation (reacting collectivity) and intense status competition and very strongly held opinions (asserting singularity and creating differential positions within the network) co-exist and are depedent upon one another. Underlying all of this is what is perhaps the meta-value of this culture: sharing. Sharing is the making available of a resource to others without the expectation of an immediate or direct return. This differentiates the act of sharing both from the exchange in the market that is always trading equivalences (e.g. goods for money) or gifts, which are expected to be returned or reciprocated at a later point as Marcel Mauss famously showed.[76] Sharing, however, is also not a charitable or altruistic act, like donating to a worthy cause that does not affect one personally, but one in which return is indirect. Rather than establishing relationships between single actors (i.e. natural or legal persons), the relationship between persons is mediated through the collective forms, such as those four mentioned above. Sharing occurs within these forms and runs on the assumption that making something available to the

collectivity is a way to advance the wider social context that provides resources for, and gives meaning to, the pursuit of one's singular goals. Thus, there is a calculus in sharing, but it's not one of individual maximisation at the expense of others. Sharing, as a value, expresses the transformation of the relationship between persons and collectives. As a method, it reduces transaction costs in a context where productive capacity is highly distributed and flexibly linked into projects that come together and dissolve easily.[77] Thus, it is a way to resolve the tension identified at the beginning of this essay, the tension between the social character of production and the private character of appropriation by putting the social character of production at the centre and private appropriation to the periphery of the system.

So What?

The phenomena described here are marginal, even if they can mobilise swarms of hundreds of thousands of people. Even the rise of weak networks as the new normal of social communication is still relatively shallow and superficial, compared to the deep institutions that continue to exert an overwhelming influence over our societies. The new institutions that I have tried to describe are very much in their infancy. They are still carried by relatively small segments of the population, mainly globalised young people. So is this all wishful just thinking? The result of particular filter bubble that makes it hard to keep all the things that are suddenly visible in proportion to all the things that have been rendered invisible?

It might well be, and its radical consequences depend ultimately on collective action. Yet, the trajectories discussed here embody one of the hopeful perspectives in a situation of deep crisis. The dominant institutions of the nation state continue to lose legitimacy on a historic scale. Inside the EU, many countries are experiencing a breakdown of democracy. In March 2013, Bulgaria had no Prime Minister after a popular revolt against the austerity measures forced Prime Minister Boiko Borisov to resign, with nobody to succeed him as an interim Prime Minister. Italy was in political deadlock after an election, which was supposed to produce a legitimate government after more than a year of rule by an unelected technocrat, rendering Peppe Grillo's anti-party the strongest party in many regions. From Greece to Ireland formally elected governments have implemented socially destructive austerity measures representing not the will of the people but those of the 'markets', that is, rich investors. In June 2013, with mass protests in Turkey and Brazil underway, the crisis of legitimacy has become visible even in countries with spectacular economic progess in the last decade.

Under the pressure of crises, even the institutions of solidarity can turn ugly. As Michael Hardt and Antonio Negri remind us, that there are many 'corrupt forms of the commons through which a desire for solidarity is channeled into practices of exclusion, expression and exploitation.'[78] We can see elements of this in forms of participatory surveillance systems and in the affirmation of local communities turning xenophobic. In its most extreme case in Hungary, but also in the rise of right-wing populism across Europe. And the commercial infrastructures of weak networks are generating 'big

data' through which to monitor, predict and thus shape social life ever more deeply, by corporations and states alike.

Yet, the crisis also offers a chance to remake society in a more inclusive and diverse way, expanding autonomy and solidarity at the same time. This will require many bridges between the islands of hope. From networked based cultures to those which can draw on sources outside the Western tradition to reinvent community and solidarity. From the new autonomous social institutions to those of the state still working in favour of the people. From social producers to market actors who can work with and contribute to common resources. There is tremendous innovation in all of these places, even in state institutions (particularly in Latin America), and the question will be how to connect the different threads so that they start to reinforce one another positively, and thus enable us to fill the void created by the waning of the culture and the institutions of the Gutenberg Galaxy.

Acknowledgements

My thinking owes its shape to an infinite number of exchanges through texts, discussions, films, and events, that is, through living, like everyone else, in a hyper-connected culture. Often, insights that turn out to be meaningful are based on chance encounters with others that are hard to remember specifically. Ideas and thoughts flow within and across networks, driven by the desire of people to appropriate and propagate them. The fact that I claim authorship is not to interrupt this

process, but to speed it along. By accepting responsibility for the arguments expressed here and making its current form traceable in what I hope will be subject to further revisions, by myself and by others.

Still, the murmur of discourse is not all. There are individals and settings that have been particularly important. One is nettime which, even after close to two decades, remains for me one of the most inspiring groups of people, many of them friends by now, for sophisticated, non-disciplinary work in trying to understand our techno-cultural conditions from within and in real time. Another is the loosely organised research project Techno Politics to which I contribute a little and from which I take a lot. Then there is the sprawling free culture movement, which has been inspiring and upsetting me for the last decade in very productive ways, particularly at one of its most restless nodes, the Free Culture Forum in Barcelona. The same holds true for the commons movement, and one of its most productive nodes, the P2P Foundation. But the world is not all distributed networks. Important for my grounding are the World Information Institute which forms my home base in Vienna and my students at Zurich University of the Arts, who help me understand what is obvious to them. The book has been written in the nexus of *Mute* magazine and the Post-Media Lab, Leuphana Universty, demonstrating that longterm independent collaboration and institutional work can coincide. Beyond solidarity, there is love and without it, nothing matters. I'm immensely grateful for those who bring it into my life and enable me to bring it into theirs.

Footnotes

1 Giulia Dessi, 'The Icelandic Constitutional Experiment', *Open Democracy*, 23 October 2012. http://www.opendemocracy.net/ giulia-dessi/icelandic-constitutional-experiment

2 Thorhildur Thorleifsdottir, 'From the People to the People, a New Constitution', *Open Democracy*, 13 November 2012, http://www.opendemocracy.net/thorhildur-thorleifsdottir/ from-people-to-people-new-constitution

3 Website of the Constitutional Council, http://www.stjornlagathing.is/english/

4 Thorvaldur Gylfason, 'Democracy on Ice: A Post-Mortem of the Icelandic Constitution', *Open Democracy*, 19 June 2013. http://www.opendemocracy.net/thorvaldur-gylfason/ democracy-on-ice-post-mortem-of-icelandic-constitution

5 Marshall McLuhan, *Gutenberg Galaxy*, Toronto: University of Toronto Press, 1962.

6 He wrote: 'The effects of technology do not occur at the level of opinions or concepts, but alter sense ratios or patterns of perception steadily and without any resistance.' Marshall McLuhan, *Understanding Media: The Extensions of Man,* Cambridge, MA: MIT University Press, 1964/1994, p.18.

7 McLuhan (1964), op. cit., p.16.

8 Castells argues that only capitalism managed to overcome what he calls 'industrialism' and move into a new paradigm of informationalism, whereas Soviet socialism stagnated and eventually collapsed unable to transform itself. Following McLuhan's terminology, one could say that capitalism managed to escape the Gutenberg Galaxy whereas Soviet socialism did not. See Manuel Castells, *End the Millennium* (second edtion), Oxford: Blackwell Publishing, 2000, pp.5-67.

9 See Megan Mullen, 'Coming to Terms with the Future He Foresaw: Marshall McLuhan's Understanding Media', *Technology and Culture*, Vol. 47 No. 2, April, 2006.

10 Karl Marx, *A Contribution to the Critique of Political Economy,* 1859, http://www.marxists.org

11 The first concept is from Christopher Freeman and Luc Soete, *The Economics of Industrial Innovation* (third edition). Cambridge, MA: MIT Press, 1997. The second is from

Carlota Perez, 'Structural Change and Assimilation of New Technologies in the Economic and Social Systems', *Futures* 15/4, October 1984, http:// www.carlotaperez.org

12 See Brian Holmes' seminar on the subject of 'Three Crisis', notes at http://messhall.org/?page_id=1088

13 See David Graeber, *Debt: The First 5,000 Years.*, Brooklyn, NY: Melville House Publishers, 2011.

14 David Lyon and Zygmunt Bauman, *Liquid Surveillance: A Conversation*, Cambridge: Polity Press, 2013.

15 Manuel Castells, *Communication Power*, Oxford: Oxford University Press, 2009, p.126.

16 If the relationships among people who need to coordinate themselves flexibly are unequal, the same structural developments create social realities of intense exploitation and precariousness. See Andrew Ross, 'In Search of the Lost Paycheck', in Trebor Scholz, *Digital Labor: The Internet as Factory and Playground*, New York and London: Routledge, 2013, pp.13-24.

17 See Zygmunt Bauman, *Liquid Modernity*, Cambridge, UK: Polity Press, 2000.

18 See for example, Beate Rössler, *The Value of Privacy*, Cambridge, UK: Polity Press, 2004.

19 McLuhan, op. cit., (1964).

20 This idea was epitomised by Fukuyama's famous claim of the end of history (in the sense of no more competition to the liberal political project) and criticised as a 'one idea system'. See Ignacio Ramonent, 'One Idea System', *CTheory*, 21 Feburary 1995.

21 See Luc Boltanski and Ève Chiapello, *The New Spirit of Capitalism*, London and New York: Verso, 2005.

22 See Brian Holmes, 'The Flexible Personality: For a New Cultural Critique', eipcp.net, January 2002.

23 See Alexander Galloway, *Protocol: How Control Exists after Decentralization*, Cambridge, MA: MIT Press, 2004.

24 The Transmission Control Protocol (TCP), together with the Internet Protocol (IP), provide the 'end-to-end connectivity specifying how data should be formatted, addressed, transmitted, routed and received at the destination.' http:// en.wikipedia.org/wiki/Internet_Protocol_Suite

25 See Lee Rainie and Barry Wellman, *Networked: The New Social Operating System*, Cambridge, MA: MIT Press, 2012.

26 Manuel Castells, *Communication Power*, Oxford: Oxford
 University Press, 2009, p.121.
27 Rainie and Wellman, (2012), pp.12–18.
28 See Robert Axelrod, *The Evolution of Cooperation*, New York:
 Basic Books, 1984.
29 Modern subjectivity and the modern state are dependent
 on one another, yet their relationship is contested. While
 liberal theories see the state as derived from a particular
 subjectivity, many critical theories see subjectivity produced
 by outside forces such as mass society and state institutions.
30 http://en.wikipedia.org/wiki/Etherpad
31 http://piratepad.net/front-page/
32 See Friedrich A. Hayek, 'The Use of Knowledge in Society',
 American Economic Review, 35, (4), 1945.
33 See Yochai Benkler, *The Wealth of Networks*, New Haven,
 Conn: Yale University Press, 2006.
34 See Saskia Sassen, *Territory, Authority, Rights: From Medieval
 to Global Assemblages*, Princeton, NJ: Princeton University
 Press, 2006.
35 In 2012, Encyclopedia Britannica announced that it would
 no longer publish printed reference books, after 244 years
 in the business. Even though it still sells access to its
 online database, this now costs $70 a year, rather than
 $1400 for the printed edition. http://abcnews.go.com/blogs/
 technology/2012/03/encyclopaedia-britannica-kills-its-print-
 edition
36 Matthew Broersma, 'Proprietary vendors lose £30bn to open
 source', *ZDNet.com*, 22 April, 2008.
37 Michel Bauwens, 'The $100bn Facebook question: Will
 capitalism survive 'value abundance'?', 22 February 2012.
 http://www.aljazeera.com/indepth/opinion/2012/02/
 20122277438762233.html
38 John Robb, 'Open Source Insurgency', globalguerrillas.typepad.
 com, 21 March 2008.
39 The concept of the ideal type was developed by the German
 sociologist Max Weber. 'An ideal type', he wrote in 1904, 'is
 formed by the one-sided *accentuation* of one or more points
 of view [according to which] *concrete individual* phenomena
 [...] are arranged into a unified analytical construct.' Quoted
 from: http://plato.stanford.edu/entries/weber
40 See Elinor Ostrom, *Governing the Commons*, Cambridge, MA:

Cambridge University Press, 1990, p.90.

41 Stefan Meretz, 'Ten patterns developed by the Oekonux project image', *Journal of Peer Production*, Nr. 1 July 2012. The Oekonux project was founded in 1999 to 'research the possibilities of Free Software to fundamentally change the current political and economic structures.' http://en.wikipedia.org/wiki/Oekonux

42 For an overview see David Bollier and Silke Helfrich (eds.), *The Wealth of the Commons: A World Beyond Market and State*, Amherst, MA: Levellers Press, 2012. http://wealthofthecommons.org

43 http://www.thenation.com/article/164405/how-people-color-occupy-wall-street#

44 http://occupywallst.org/forum/first-official-release-from-occupy-wall-street/

45 http://www.aljazeera.com/indepth/opinion/2011/11/2011112872835904508.html

46 http://www.nycga.net/resources/documents/principles-of-solidarity/

47 See Elinor Ostrom, 'Design Principles and Threats to Sustainable Organizations that Manage Commons', *Workshop in Political Theory and Policy Analysis. Workshop Working Paper W99-6*, 1999. http://dlc.dlib.indiana.edu

48 David D. Clark, 'A Cloudy Crystal Ball – Visions of the Future', *Proceedings of the Twenty-Fourth Internet Engineering Task Force*, MIT July, pp.13-17, 1992, p.551. http://ietf.org

49 As an example of the extraordinary length projects are willing to engage to find consensus while transforming its mode of governance, the most ambitious challenge of self-rule, see George Dafermos, 'Authority in Peer Production: The Emergence of Governance in the FreeBSD Project', *Journal of Peer Production*, #1, July 2012.

50 Weber, (2004).

51 See Felix Stalder, 'Enter the Swarm: Anonymous and the global protest movements'. *Le Monde Diplomatique*, February 2012. The memorable phrase quoted is from Clay Shirky. *Here Comes Everybody: The Power of Organizing Without Organizations*, New York: Penguin Press, 2008. For a critique see Felix Stalder, 'Analysis Without Analysis', metamute.org, 28 June 2008.

52 See Gustave Le Bon, *Psychologie des Foules*, 1896. Available

as 'The Crowd: Study of the Popular Mind', Batoche Books: Kitchener, 2001 (online).

53 See Harry Halpin, *The Philosophy of Anonymous: Ontological Politics without Identity, Radical Philosophy,* No. 176, Nov/Dec, 2012.

54 Rik Falkvinge, *Swarmwise: What is a Swarm?*, 8 January 2011. http://falkvinge.net/

55 Shirky, (2008)

56 Brian Holmes, 'Swarmachine', Continental Drift Blog, 21 June 2007. http://brianholmes.wordpress.com/2007/07/21/swarmachine/

57 http://newsroom.fb.com/News/457/One-Billion-People-on-Facebook

58 http://www.pewglobal.org/2012/12/12/social-networking-popular-across-globe/

59 See Marc Granovetter, 'The Strength of Weak Ties', *The American Journal of Sociology,* 78 (6), 1973, pp.1360–1380. His foundational definition of the strength of a tie is the following, 'a combination of the amount of time, the intensity, the intimacy (mutual confiding) and the reciprocal services.' p.1361.

60 Stanley Milgram, 'The Small World Problem', *Psychology Today*, May 1967, pp.60–67.

61 https://www.facebook.com/notes/facebook-data-team/anatomy-of-facebook/10150388519243859

62 This idea was later picked up by Bruno Latour who claimed that here is only the micro-level and that what appears to be macro is simply a very long chain of micro-transactions.

63 See Eli Pariser, *The Filter Bubble: What the Internet Is Hiding from You*, New York: Penguin Press, 2011.

64 See Casey Johnston, 'Is Facebook 'broken on purpose' to sell promoted posts?', arstechnica.com, 5 November 2013. Nick Bilton, 'Facebook News Feed Draws More Criticism', bits.blogs.nytimes.com, 5 March 2013.

65 http://blog.instagram.com/post/38252135408/thank-you-and-were-listening

66 See Tiziana Terranova, 'Free Labor: Producing Culture for the Digital Economy', http://www.electronicbookreview.com, 20 June 2003.

67 Following the classic Marxist argument, Christian Fuchs, for example, argues that the rate of exploitation is 'infinite' since

the labour costs are zero (users are not paid to generate data) and surplus (profits) is being generated. While this is technically correct (the rate of exploitation in Marxist theory is calculated as a function of labour costs and surplus) this infinity is not the result of an unprecedented exploitation but of the inadequacy of the formula. See Christian Fuchs, 'Class and Exploitation on the Internet', in Trebor Scholz, 2013, pp.211-224.

68 Steffen Boehm, 'The Value of Marx: Free Labour, Rent and 'Primitive' Accumulation in Facebook', *Working paper*, University of Essex, May 2012.

69 David Harvey, 'The Art of Rent', Socialist Register, Vol. 38, 2002, p.94.

70 Manuel Castells, *Networks of Outrage and Hope: Social Movements in the Internet Age*, Cambridge, UK: Polity Press, 2012, p.230.

71 See Fred Turner, *From Counterculture to Cyberculture: Stewart Brand, the Whole Earth Network, and the Rise of Digital Utopianism*, Chicago: University of Chicago Press, 2006.

72 See Castells, (2012).

73 See Gerald Raunig, *Factories of Knowledge, Industries of Creativity*, Los Angeles: Semiotext(e), 2013.

74 See Sherry Turkle, *Life on the Screen: Identity in the Age of the Internet*, New York: Simon & Schuster, 1995.

75 See Mathieu O'Neil, *Cyberchiefs: Autonomy and Authority in Online Tribes*, London: Pluto Press, 2009.

76 See Marcel Mauss, *The Gift: Forms and Functions of Exchange in Archaic Societies*, London: Cohen & West, 1966.

77 See Yochai Benkler, 'Sharing Nicely: On Shareable Goods and the Emergence of Sharing as a Modality of Economic Production', *Yale Law Journal,* Vol. 114, 2004, pp.273-358.

78 See Michael Hardt and Antonio Negri, *Commonwealth*, Harvard, MA: Harvard University Press, 2012.

Lightning Source UK Ltd.
Milton Keynes UK
UKHW041507311022
411393UK00002BA/24

9 781906 496920